Nick Vandome

Create Great Photos Using Your Smartphone

in easy steps

In easy steps is an imprint of In Easy Steps Limited
16 Hamilton Terrace · Holly Walk · Leamington Spa
Warwickshire · United Kingdom · CV32 4LY
www.ineasysteps.com

Notice of Liability
Every effort has been made to ensure that this book contains accurate and
current information. However, In Easy Steps Limited and the author shall
not be liable for any loss or damage suffered by readers as a result of any
information contained herein.

Trademarks
All trademarks are acknowledged as belonging to their respective
companies.

In Easy Steps Limited supports The Forest Stewardship Council (FSC), the
leading international forest certification organization. All our titles that are
printed on Greenpeace approved FSC certified paper carry the FSC logo.

MIX
Paper from
responsible sources
FSC® C020837

Printed and bound in the United Kingdom

ISBN 978-1-84078-868-6

Contents

Using Camera Settings

On traditional digital cameras, the various settings can be accessed from buttons or controls on the body of the camera, and also from a menu that is usually viewed on the screen on the back of the camera. However, camera phones do not have this functionality on the body of the smartphone. Instead, settings can be accessed from the screen of the camera app and also within the smartphone's Settings app. This is where a range of settings can be applied for the smartphone, including those relating to the camera. To access camera settings on a smartphone:

1 Tap on the **Settings** app

2 Tap on the **Camera** option within the Settings app

3 A range of settings can be applied for the camera, depending on the make and model of smartphone. (Other settings, such as flash and self-timer, can be accessed from the camera app)

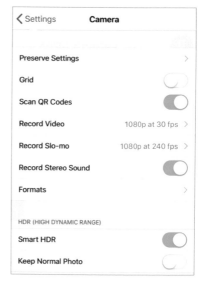

Getting on the Grid

Composition is one of the key elements of good photography; i.e. where subjects are placed in a photo. Generally, the main subject appears in the center of a photo, but there are good artistic reasons to move the main subject to other areas of the photo. This can be done visually when composing a photo with the smartphone's camera app. However, it is possible to make this process slightly easier by displaying a grid over the scene that is being viewed. This is a 3 x 3 grid that produces nine segments: the main subject can then be positioned within any segment (or at the intersection point between segments) to create a more artistic composition. The grid can be displayed or hidden within the camera settings:

1 Access the camera settings as shown in Tip 2

2 Tap on the **Grid** option so that it is **On**

Grid	

3 When the camera app is opened, the grid is superimposed over the scene being viewed (the grid does not appear in the final photo)

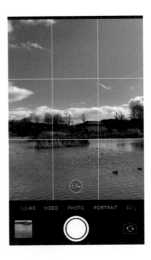

Reducing File Size

Digital photos captured on a smartphone are made up of pixels. These are tiny colored dots that combine to make the overall photo. They also contribute to the physical file size of a photo: the greater the number of pixels that make up a photo, the larger its file size. The number of pixels also determines the quality of a photo: the more pixels, the higher the quality of the photo. However, this does not mean that photos have to necessarily be captured at the largest file size available: for photos that will be emailed or shared via social media, a smaller file size can be just as effective in terms of displaying photos. A larger file size is better if photos are going to be printed.

Smartphone cameras usually have a default to take photos at the largest possible size; i.e. the greatest number of pixels. This takes up more space when they are stored on the smartphone so it is possible to specify a smaller file size at which photos are captured:

1 Access the camera settings as shown in Tip 2

2 Tap on the required setting for file size – e.g. **Formats**

Formats

3 Select one of the formats that produces a smaller file size for photos

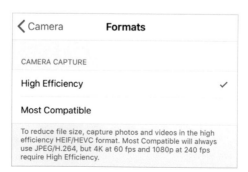

‹ Camera	**Formats**	
CAMERA CAPTURE		
High Efficiency		✓
Most Compatible		

To reduce file size, capture photos and videos in the high efficiency HEIF/HEVC format. Most Compatible will always use JPEG/H.264, but 4K at 60 fps and 1080p at 240 fps require High Efficiency.

Working With Filters

Filters are artistic effects for digital photos that can give them a significantly different and frequently improved appearance. Filters can be added when photos are edited using a photo-editing app and they can also be applied when a photo is taken with a smartphone camera. If this is the case, the original photo will have the filter applied to it: if you want to capture a realistic version of a scene, take a photo of it without a filter first. Another photo, using a filter, can then be taken afterwards. To apply a filter when a photo is being taken:

1 Open the smartphone's **Camera** app

2 Tap on the **Filter** button

3 Tap on one of the filter options to apply it to a photo before it is taken

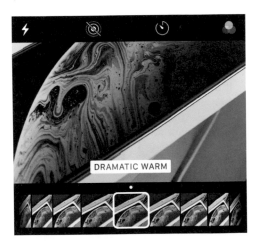

DRAMATIC WARM

4 Capture the photo. The filter will be applied and will stay selected until another filter is selected or the **Filter** button is turned **Off**

Default camera apps on smartphones tend to have a limited number of options in terms of the amount of control that you have over the photo-taking process. However, third-party apps have a wider range of manual options that can be applied when taking photos. These include controls for:

- **Exposure**. This can be used to determine the amount of light that is being analyzed by the smartphone camera.

- **White balance**. As shown in Tip 9, this can be used to give the camera a default reading for how white should appear in photos.

- **Image file format**. This can be used to change the file format in which photos are captured. By default, the JPEG file format is used for digital photos taken on smartphone cameras, but other formats such as TIFF or RAW can be specified in manual settings. These produce higher-quality images in terms of the amount of color information that is captured, but this is rarely visible to the naked eye. TIFF and RAW formats also produce larger file sizes.

- **ISO equivalent film speed**. This is a setting that refers to traditional film cameras and relates to the sensitivity in terms of how much light is viewed by the camera. The term ISO is still used for digital cameras and it can be changed to make them more, or less, sensitive to light. This can be used in low-level lighting situations: a higher ISO setting will enable photos in low-level lighting to be captured more effectively, by allowing more of the available light to be viewed by the camera.

- **Light compensation**. This is known as an EV number and can be used to artificially increase or decrease the amount of light being viewed by the smartphone camera when taking a photo.

Using Manual Controls

Manual camera apps can be downloaded from your smartphone's default app store (App Store for iPhone, and Google Play Store for Android phones).

Although third-party camera apps have a wider range of functionality than default ones on smartphones, some of the options are achieved by digital wizardry rather than photographic techniques used on standard cameras. The results are not always as sophisticated as those on manual cameras, but it can improves the options for a smartphone camera.

To find and use third-party camera apps:

1 Enter **camera apps** into the Search box of your smartphone's default app store

2 Review the options and download apps as required. (Some third-party camera apps have limited options for the free version: additional functionality has to be paid for, known as in-app purchases. However, most camera apps offer a free trial period for the paid-for version)

3 Open the app and tap on one of the controls to adjust it; e.g. the shutter speed of the camera or the ISO setting (the controls are generally the same as the default camera app, but with more options)

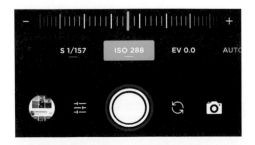

Volume Buttons for Photos

The shutter button for a smartphone's camera (the button used to take the photo) is usually at the bottom-middle of the screen. For most photographic needs this is a good location for accessing the button when taking a photo. However, there may also be times when it is not so convenient to use this button: if perhaps the smartphone is at an awkward angle, or you are stretching in order to get a better view of a subject. In instances like this it is possible to use the volume buttons at the side of the smartphone to take the photo:

1 Compose the photo as normal

2 Press the volume button (or the up or down volume buttons if the smartphone has more than one) to capture the photo

Creating Duplicates

Digital photos that have been captured on smartphone cameras can be edited in a wide range of exciting and eye-catching ways. This can be before the photo has even been captured, by applying filters, or afterwards using a photo-editing app. Smartphones have their own default photo-editing apps, and third-party ones can also be downloaded from the smartphone's connected app store. Third-party photo-editing apps usually have a wider range of functionality than the smartphone's default one.

When editing photos on a smartphone, it is important to retain the original in case you want to return to this once editing is completed. If a photo is having a filter applied to it before it is taken, it is a good idea to also take the same photo without the filter so that there is a version that has not been digitally enhanced that can be used.

To ensure that you always have an original photo of a subject, regardless of any editing that may be done to it, take two photos of the same subject, so that one can be used for editing purposes. Another option is to make a copy of a photo once it has been captured. To do this:

1 Open a photo-editing app

2 Select a photo within the app

3 Select the **Duplicate** option within the photo-editing app

Duplicate

Smartphone cameras are very adept at focusing on the scene in front of them, known as Auto-Focus (AF). However, by default they try to focus on as much as possible in the scene. On most occasions this is what is desired, but there may be times when you want to have the main focus of the photo at one specific point. If this happens, the smartphone camera will still try to get as much of the rest of the photo in focus as possible, but the area that you have selected will be the main focal point.

To specify a specific focal area in a photo:

1 Open the Photos app and compose a scene

2 Press and hold on the screen on the area that you want to be the main focal area

3 A colored square appears over the focal area

4 Keep holding on the screen until the **AE/AF Lock** button appears at the top of the screen (AE is for the exposure of the image – see Tip 15 – AF is for the Auto-Focus). This indicates that the focal point has been set where you specified it and will remain there once you remove your finger from the screen and move the camera

Getting the Right Exposure

When a smartphone camera looks as a scene, it assesses the amount of available light and applies settings accordingly to ensure that photos have the best and most consistent lighting possible. This is known as the exposure of a photo and it is done automatically by assessing the light in the whole scene, using a matrix that takes a light reading throughout the scene. This results in photos where the darkest and lightest areas of a photo are exposed as well as possible. However, there will be times when even this sophisticated method of assessing the amount of light in a scene produces results where either the dark areas are too dark or the light areas are too light, known as being "burned out". If this happens, it is possible to manually select an area of a scene where you want the exposure reading taken. For instance, if you want to ensure that a light area of sky is exposed correctly, take a reading from that point. The downside of this is that the rest of the photo will then use the same exposure reading, sometimes rendering it too dark or light. To select an exposure manually:

1 Open the Photos app and compose a scene

2 Press and hold on the screen on the area that you want to be the main exposure area, in the same way as for locking the focal point

3 The **AE/AF Lock** button appears in the same way as in Tip 14, to indicate that the exposure has been locked at the point within the colored square

4 If required, drag the slider at the side of the colored square to alter the exposure for the selected area

Bracketing and HDR

There are some photographic scenes that we can capture numerous times; e.g. those close to our home. However, at times there will also be locations and photographic opportunities that may be a one-off. In cases like this it is important to try to get the best shots possible, in case you do not get the chance again. One way to do this is to take each shot at different exposure settings, known as bracketing. This can be done manually by changing the exposure for different shots, by pressing on the screen at different points to lock the exposure, as shown in Tip 15.

 Press and hold on the screen to select the exposure for a specific area of a scene, and take the photo. Press and hold at another point to alter the exposure of the scene, and take another photo. Repeat this as often as required

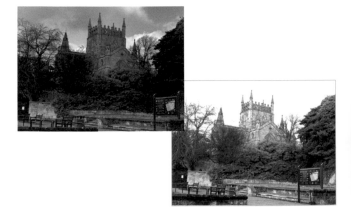

Also, some smartphone cameras can bracket photos automatically using a technique known as HDR (High Dynamic Range). This takes at least three photos at different exposures, and then combines them to create one photo with the ideal exposure. HDR mode can usually be accessed from a button within the smartphone's camera app, or within the Settings app.

Zooming In and Out

Smartphone cameras have a zoom function, so you can make subjects appear larger on the camera's screen. However, unlike traditional cameras, which use an optical zoom by changing the distance between the camera's internal lenses, digital zoom is the same as cropping a photo, or zooming in on it using a photo-editing app. Digital zoom works by increasing the size of the pixels on the screen and produces an inferior quality than using optical zoom. It is therefore important that zooming is not overused on smartphone cameras: the greater the amount of zoom, the greater the reduction of image quality (and the same effect can be achieved by cropping a non-zoomed photo). However, it can still be useful to use a certain degree of zoom, and there are two ways to do this:

1 Swipe outwards with thumb and forefinger to zoom in on a scene with the camera app

2 Swipe inwards with thumb and forefinger to zoom out on a scene

3 The amount of zoom is displayed at the bottom of the screen

4 Tap on the zoom button and drag it to change the zoom level by smaller incremental amounts than by swiping

Steady as it Goes

One of the most common causes of blurry photos is camera shake. This occurs when the camera is moving slightly when a photo is taken, caused by small movements in the hand of the person taking the photo. A lot of smartphone cameras have a technology known as image stabilization that is very effective at reducing camera shake, but there will be times when you want to keep your smartphone as still as possible when taking a photo (this is particularly applicable as it can sometimes be difficult to keep a smartphone steady when taking a photo with one hand). Some options for keeping your smartphone camera steady are:

- Use an existing surface, such as a bench, wall or a railing, to steady your arm and the smartphone.

- Carry a small beanbag with you to place the camera on when you need to keep it steady.

- Use a small tripod to keep the smartphone steady at all times. Some tripods have legs that can be bent into different positions so that the smartphone can be kept steady and level on uneven surfaces.

Basic Maintenance

Unlike traditional cameras, smartphone cameras generally do not have as many accessible moving parts. This means that they are less susceptible to damage through the everyday irritants such as dirt and dust. However, there are still a few steps that can be followed to ensure that your smartphone's camera remains in the best condition:

- Keep the lens clean. If specks of dust or dirt are on the lens these could show up in photos. Use a soft, lint-free cloth (similar to those used to clean spectacles) to clean the lens, particularly at times when you are taking an important photo.

- Regularly inspect the lens for any physical damage, such as scratches. If the lens is scratched this will impact on all of your photos.

- Use a phone cover that has a raised edge to protect the camera: if the phone is dropped, the cover's edge should hopefully save the camera from any damage.

- Avoid extremes of heat or cold. These could affect the overall operation of the smartphone and therefore impact on the efficiency of the camera.

Natural sunlight is one of the best conditions for taking photos. It produces a range of lighting options and can be used to take snapshots or more creative images. However, there can be some issues when taking photos on bright, sunny days. The principal one is avoiding glare in a photo when taking shots directly into sunlight: the resulting images can contain a flare of light as a result of looking into the sun. This does not mean that you should not take photos into the sun; just be aware of the dangers of glare and how to avoid it.

1 If a scene is directly into sunlight, there could be glare on a screen

2 Use your hand over the top of the camera, or use a book or a piece of card, to shade the camera and remove the glare (be careful that there is no shadow over the camera on the screen from the item shading it)

Rotating Your Photos

One of the quickest and easiest ways to change the composition of a scene is also one of the most effective: simply turn the smartphone 90 degrees. This changes the orientation from landscape to portrait, or vice versa. It can have a dramatic effect on the scene, and since it only takes a few seconds to do, it is worth considering this for most photos that you take.

● Landscape photos give more emphasis to the vertical aspect of a scene.

● Turn the smartphone 90 degrees to portrait orientation, which gives more emphasis to the horizontal aspect of a scene and creates a significantly different photo.

Tip 3 showed how to display a 3 x 3 grid over a scene being displayed on a smartphone's camera. This is used for composing a photo, by moving the main subject within the grid. This is a regularly-used photographic technique and, because of the type of grid that is used, it is known as the Rule of Thirds.

The Rule of Thirds can be used to position a main subject within any of the nine segments that are created by the 3 x 3 grid, or at any of the intersection points. If you have a particularly appealing scene in front of you, it is worth experimenting by taking several photos, positioning each one in a different location according to the Rule of Thirds. This can create significantly different end results.

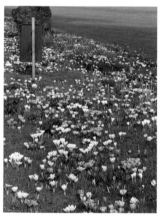

Embracing Empty Space

Empty space in a photo, also known as negative space, is something that should be considered as a positive composition tool rather than an issue to be ignored. Empty space is the area that is not occupied by the main subject of a photo (and usually devoid of content). It can be used to draw attention to the main subject, by emphasizing the contrast between the two: if there is a large amount of empty space, it can draw the eye to the main subject in a way that is not achieved by balancing the empty space and the subject.

Empty space can be used with objects, landscapes, landmarks, and people.

Framing Effectively

Photos or pictures always look better in an appropriate and attractive frame, and the same is true for photos when they are taken. If the main subject can be framed in an interesting or artistic way, this can add considerable impact to the final photo. Framing options exist with natural or man-made elements:

- Use branches of trees to frame a landmark or a landscape scene.

- Use architectural elements to frame a specific item.

- Use an existing window frame or doorway to create a ready-made frame for a photo.

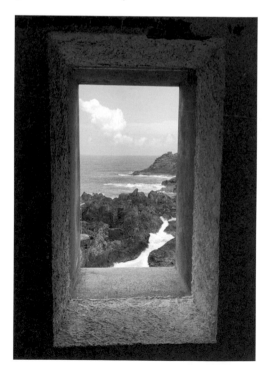

Identifying Symmetry

Symmetry, in the natural world or man-made, is an excellent option for eye-catching and artistic photos.

Finding symmetrical subjects to photograph can be a challenge, but if you set your mind to looking for symmetrical scenes you may be surprised how many you start seeing: part of capturing good photographic scenes is to start thinking like a photographer.

- Look for a combination of man-made features and natural components to create effective symmetry.

- Reflections are an ideal way to create symmetrical photos, using either water or glass.

- Buildings contain numerous elements of symmetry, either close-up or from a distance.

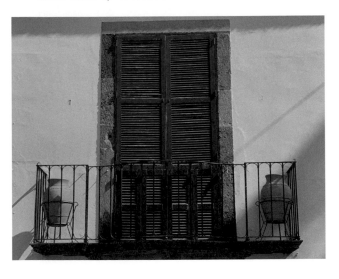

Looking for Lines

Good photographs are those that draw the viewer's eyes through the photo. This can be by emphasizing the main subject by using empty space, using the Rule of Thirds, or by using lines in a photo to act as a guide for where the viewer is intended to look.

- Use straight lines such as roads, railway tracks, paths, or staircases to draw the viewer's eye through a photo and create a sense of depth in the image.

- Use curved lines to create a more fluid path through a scene or setting.

Perfecting Patterns

Patterns occur all around us, and they are ideal for photography. They can give a real sense of character to a building or as a detail in nature.

When taking photos of patterns, try to get as close as possible, to capture the greatest amount of detail. For some subjects, it is effective to take wide-angle shots of the whole thing and then some close-ups of patterns, to capture the overall character of the subject.

Patterns do not have to be symmetrical, and the important thing to remember is that they can occur almost anywhere. They are also an excellent way to show the texture and color of objects.

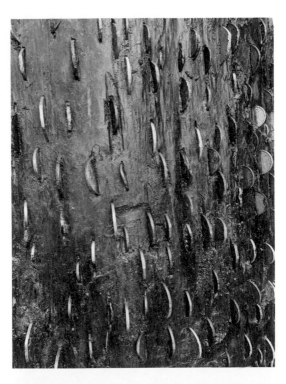

When taking photos of natural objects, a whole new world of photographic possibilities can be unearthed simply by moving closer to something and concentrating on its detail. This can reveal a degree of interest that is missed in a photo taken from a distance. For instance, a leaf taken from a distance just looks like a small green mark. However, a close-up reveals its intricate detail and produces a dramatic and effective photo.

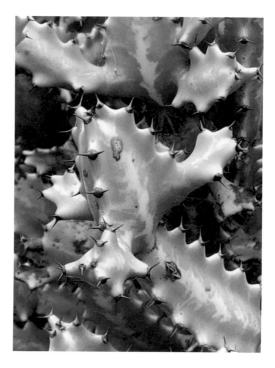

Similarly, pebbles on a beach from a distance can be unremarkable. Move closer and they reveal a myriad range of colors and textures.

Whatever you are photographing, always consider taking a close-up, if possible, to capture the detail of a subject.

Making it Natural

Natural light is the best friend of a photographer. However, it is not always the case that as soon as you see the sun shining, you should rush outside with your smartphone camera. Timing is important when using natural light: at midday when the sun is directly overhead there can be little contrast of subjects, and the resulting photos can look somewhat severe.

When using natural light it is best to wait until the sun is at an angle, creating a softer lighting effect. This is also more likely to create some shadows (because of the angle of the sun) that can be used to artistic effect in photos.

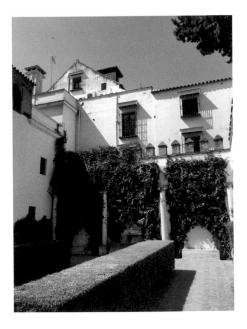

Even when taking photos in natural light it is not just about the light itself; it is about the overall lighting effect in a scene and how this can be used to create a well-balanced and well-lit photo.

For the best photographs, the ideal natural lighting conditions usually occur approximately one hour after sunrise and one hour before sunset. In photographic terminology this is known as the Golden Hour.

The reason that the Golden Hour is so good for photography is because of the angle at which the light hits its subjects, and because at these times it produces a deep glow rather than the harsh glare of midday sun. The morning and the evening Golden Hours produce slightly different effects: the morning sun has a soft golden effect, while the evening sun tends to have a stronger orange glow with a bit more depth to it.

The other thing to be aware of about the Golden Hour is that it is short. This means that you will not have a lot of time to move from location to location. It is best to pick a subject that you want to capture and then concentrate on a few top-quality shots.

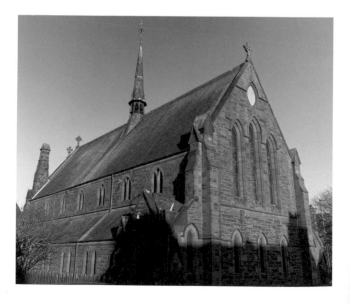

Into the Blue/Purple Hour

Similar to the Golden Hour, the Blue Hour (sometimes known as the Purple Hour too) is a slightly shorter period of time, occurring in the morning just before the sun rises, and in the evening just after the sun sets, but there is still some light in the sky. Depending on the weather conditions – i.e. if there are clouds to reflect the diminishing light or not – or just the sky, this can create scenes with a blueish/purple tinge. The Blue Hour can be thought of as occurring just before the Golden Hour (in the morning) and just after it (in the evening). Also, the Blue Hour is usually slightly shorter than a full hour in duration.

The Blue Hour is best for capturing city scenes and landscapes. For city scenes, the lights of the city, or structures, can contrast with the blue effect created by the lack of direct sunlight.

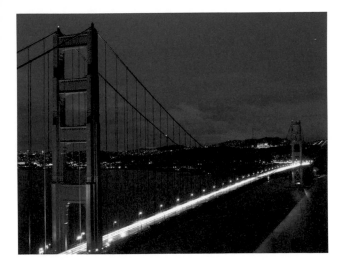

Where possible, keep your smartphone as steady as possible when capturing Blue Hour shots, as the lack of light will mean that there is more chance of a blurry image if the smartphone is not held firmly in position.

Although the Golden Hour can produce stunning photographic results, it usually takes a bit more effort on the part of the photographer. In the morning you will have to be up and away before sunrise, and in the evening you may not finish shooting until well into the evening. The essential thing is to make the most of these lighting opportunities when they present themselves. This may mean checking out a few shooting locations during normal daylight hours so you know exactly where to go when the Golden Hour occurs. You do not want to be wasting time finding locations when the light is at its best. A bit of forward planning can make all the difference when dealing with the Golden Hour.

One issue with photographic timing is the actual time of day during which you are shooting. Sometimes you do not have any control over this but if you have the chance to capture images at times of your choosing then this opens up a variety of creative possibilities. Whenever you are going to take photos, check the times of sunrise and sunset (particularly if you are in an unfamiliar location) and work out the position where the sun will rise and set. This will enable you to work out the best locations at certain times of the day. If you know the timing of the best light in the day, you will then be able to make sure you are in position to utilize it for as long as possible.

Another way to check what the lighting conditions may be for a certain time of day is to look at the local weather forecast for where you are. This can give an indication of what the weather may be like, and you can adjust your photography exploits accordingly: if you were hoping to take photos on a bright sunny day this may be dashed if the forecast is for thunderstorms, although this can produce photographic opportunities of their own. Some photography websites have weather timings for the appearance of the Golden Hour and the Blue Hour, so it is worth checking these for your location.

It's All About Timing

As with many aspects of life, timing is important in photography, for ensuring the best photos. This involves the time of day at which you are capturing images and also the amount of time you spend when you are taking a shot: it is easy to rush photo-taking, but it can be beneficial to spend time over one shot to ensure that it is the best you can achieve, rather than take several shots quickly without any of them turning out perfectly.

Another issue with timing covers the physical process of capturing images. Frequently in photographic situations it is all too easy to rush the image-capturing process. This can be exaggerated if you are faced with an especially enticing scene: the tendency is to rattle off a lot of images quickly in order not to miss the shot. Before you do this, it is a good idea to create a checklist for capturing the best photos possible. It will only take a few moments and bring significant rewards later:

- Make sure that the lens of the smartphone camera is clean (use a lint-free cloth or a glasses cloth).

- Check your smartphone camera settings. If you change the setting for a certain shot, these settings will be retained until you change them again.

- Ensure you have the best composition.

- Keep the smartphone steady.

- Focus accurately and then capture the image. Quality over quantity wins every time.

Sometimes just a few minutes can make all the difference to an image. Waiting for a cloud to move so that the sun comes out to illuminate your subject can turn an average image into a standout one, even if you have to stand and wait for a few minutes. If you are aware of your surroundings you can time your photo-taking accordingly.

Two of the commonest light sources in photography are front lighting and side lighting. Front light occurs when the main source of light is behind the photographer and facing the subject. This creates a more even exposure but you have to be careful about the time of day when capturing front-lit subjects outside. If it is too near midday, the sun will be too high in the sky. This will result in images that appear too harsh and without much contrast: the sun at this time is at its brightest but this gives a "flat" light in photographic terms. In terms of lighting conditions for consistently good images, front light is the best bet.

The other main type of lighting is side light. This is where the main light source is at the side of the subject. This is a particularly effective lighting source for portraits, since it provides a good contrast on the subject's face: one side is brightly lit, while the other is in shade. However, it is important to get the balance right or else the contrast between the two will be too great.

Backlit Subjects

Although front lighting is a common option for a variety of photographic situations, it can have its disadvantages too. One of these is seen when capturing images of people. If the main subjects are lit from the front they may appear bright, but the light inevitably causes them to squint or shade their faces from the bright sunlight. This usually results in a very unnatural and strained-looking portrait.

One solution to this problem is to position the subjects with the sun behind them. This removes the strain on their eyes and allows them to look more relaxed. However, this causes its own problems as the back lighting results in their faces being in shadow.

The solution to this problem lies in a technique known as fill-in flash. It may seem strange to use the flash when you are outside in the sun, but this is the best way to ensure a well-balanced portrait when a subject is backlit by the sun. To achieve this, you have to actively turn on the flash to fire on every shot. Once the flash has been activated it is just a case of taking the shot as normal. Another way to capture this type of image is to use a light source to the side of the subjects. This can produce the most sympathetic lighting effect and means that fill-in flash is not required.

Reflections in Water

Water offers numerous photographic opportunities, and one of these is capturing reflections. This can be done for a range of subjects and also differing water conditions.

- Landscapes are an ideal subject for reflections in still water, such as a lake or the sea.

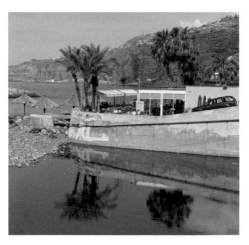

- Close-ups of items captured in water are an excellent way to create artistic images.

- Rippling water is also excellent for creating artistic reflections.

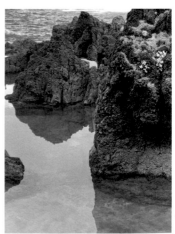

Reflections in Objects

Water is not the only thing that can be used to create reflections when taking photos; anything with a reflective surface can be used to create a striking photo:

● Use sunglasses to capture the reflection of an object or a person.

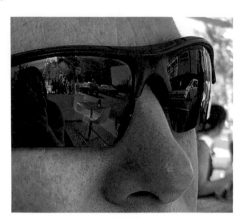

● Use car wing mirrors to capture an interesting foreground and background.

● Use glass on a building to create an eye-catching architectural effect.

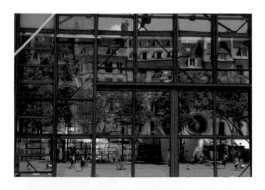

One of the simplest ways of improving the composition of photos taken with your smartphone camera is to change the position from where you are taking photos. Even a small movement can have a dramatic effect on the final image:

- Start by taking a standard, straight-on shot of your subject.

- Get as low as possible (this can sometimes result in some strange looks from people around you) to emphasize size in buildings, or create a larger foreground in a photo.

- Find a higher viewpoint to look down on a subject, rather than looking up at it.

Moving the Horizon

When taking photos straight-on, it is a natural reaction to keep the horizon in the middle of a photo. This is a good option, but moving the position of the horizon in a shot is another effective way to change the perspective of a scene.

1 Take a photo with the horizon in one position of the frame

2 Move the position of the horizon to the top or bottom of the frame to see how this alters the overall effect in the photo

Smartphone cameras are generally located near to the edges of the phone's body. One of the issues with this is that there is the potential for inadvertently getting your fingers or thumb in a photo, by covering some of the camera lens when you are taking a photo. This can spoil what would otherwise be an impressive photo:

Some ways to avoid getting your fingers or thumb in a photo by mistake include:

- Hold the smartphone lightly by the edges, rather than grasping too firmly, which can cause your fingers or thumb to overlap the camera lens.

- Always review your photos in the photos app before you leave a location: if there are photos where your fingers have overlapped the lens, take them again.

- If you do end up with fingers or a thumb in a photo, try cropping the photo to remove them. This may not produce a perfect photo, but it should be better than the alternative.

Going Over the Edge

A common composition mistake is to cut off subjects at the edge of the frame in a photo. This can be the top of someone's head, part of a building or an element in a landscape. The temptation to get everything as large as possible in the frame can result in parts getting too close to the edge. One way to avoid this is to leave a larger border and then crop the photo afterwards if required.

1 Having subjects too close to the edge of the photo can reduce its effectiveness and impact

2 Leave a generous border around the main subject when you take a photo to ensure that no elements are cut off

When faced with an attractive scene or landscape it is tempting to point your smartphone camera at it and snap away. This can produce some excellent photos, but in addition to this an added feature can be created by including specific objects in the foreground. This gives another element of interest and can give your photos that extra "wow" factor. This can take a bit more effort to compose the photo so that it includes the foreground object, but is something that will pay great dividends.

Foreground objects can include natural elements such as trees or flowers, and also man-made items too.

Into the Night

Just because the sun has gone down does not mean that you have to put your smartphone camera away until the next day. There are endless opportunities at night to take breathtaking photos. Some areas to consider:

- Look for landmarks that are lit up. It is now common for an assortment of buildings to be illuminated in cities around the world, and these present great photo opportunities.

- Use streetlights and lamps for lighting up items to be photographed.

- Include car headlights to create streaked effects.

- Look for water features, such as fountains, that are lit up at night.

While light is one of the main elements required for good photography, its counterpart, shade, should not be underestimated. When shade is combined with a brightly lit photo, it can add contrast and levels of subtlety that were not previously there.

Try to find scenes where the light and the shade balance each other out, or where the shade adds an extra element to the photo, such as the shadow of leaves falling over a brightly tiled wall. This can create a much more interesting shot than one simply in bright sunlight.

Relaxing Subjects

Given the proliferation of smartphone cameras, it is very easy to take numerous photos of family and friends. However, the ease with which this is done is also one of the reasons why portrait shots are not always as good as they could be. Just because it is easy to take photos of people with your smartphone camera it does not mean that a certain amount of care and attention should not also be used.

One factor when capturing portraits is to make the subject(s) as relaxed as possible. There are a number of ways to try to achieve this:

- Talk to them before you start taking pictures and tell them what you want to do. This should help relax them, and you will both be working for the same end result.

- If possible, take as much time as you can when taking photos of family and friends. If someone is presented with a camera pointing at them and asked to strike the perfect pose, they may understandably be a little self-conscious. The longer that you can spend with your subject(s) the more relaxed they will become about the idea of having their photo taken. The ideal situation is to reach a point where they are barely aware that you are taking photos with your smartphone camera.

- In some cases it will be beneficial to give the subject some type of prop (especially if children are involved). See Tip 46 for details.

- To try to capture the best facial expression, ask the subject to look down and close their eyes. Then, on the count of three, ask them to open their eyes and look up. If you capture the image at this point, it should create a more natural expression as the subject will be less self-conscious.

- Let people see the photos as you are taking them. This will enable them to make any adjustments as required.

One of the issues with photos of people is that they can become self-conscious when they are facing the camera. An option for overcoming this is to use props when taking photos of people, to distract them while the photo is being taken. Props can take a variety of forms:

● Give the subject a puzzle to do, such as a Rubik's cube or a Sudoku puzzle. Give them some time to get involved with the puzzle and then start taking photos when they are concentrating fully.

● Take a photo while the subject is reading a book. Similarly as with a puzzle, give the subject time to become engrossed in the book so that they are not self-conscious about you taking a photo.

● Ask the subject to perform some form of physical activity such as throwing and catching a ball or playing in a playground.

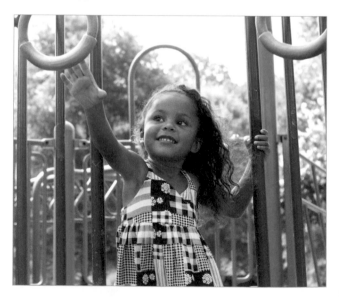

Perfecting Selfies

Selfies are very much a phenomenon of the smartphone camera age. These are self-portraits that are taken using the back-facing camera on a smartphone; i.e. the one that you look at when you are looking at the screen of the smartphone. Selfies are frequently used to upload to social media sites, directly from the smartphone. Although selfies are very quick to take, there are some issues to consider:

- **Treat them for what they are**. Selfies are rarely going to reach the pinnacle of photographic excellence, and they should be treated as a bit of fun that can be shared with family and friends. If you want to get a more professional photo of yourself, ask someone else to take it or use the self-timer (see Tip 52).

- **Selfie sticks**. Few things divide the photographic world as much as selfie sticks. These are devices that the smartphone is attached to and then selfies can be taken from a greater distance away from the subject, operated by a button on the selfie stick. To some they are the ultimate mobile accessory; to others an intrusive contraption that has become an eyesore. But love them or hate them, it is undeniable that they can produce more effective selfies, because of the extra distance away from the subject and the greater amount of background that can be included in the photo.

- **Keeping safe**. There have been instances from around the world where people have come to harm by taking selfies in dangerous locations, such as near the edge of cliffs. This is reckless in the extreme, and you should never put yourself or others in danger when trying to take a selfie. If you are near a drop of any kind, always make sure that you know where your feet are. Do not feel tempted to edge one way or another without first looking exactly where you are going to place your feet. Also, do not rely on someone else's judgment if they are telling you where to move – always look first, regardless of what someone is saying.

Capturing Candid Portraits

A good portrait may adorn your wall or mantelpiece for many years, and it is one of the most common ways to capture images of people. But un-posed or candid shots can be just as appealing, and they offer a different type of insight into the character of the subject.

Candid shots can be captured on the spur of the moment, when an appropriate opportunity presents itself. However, there are also some steps that can be taken when capturing candid shots of people around you:

- The best way to capture candid shots is to ensure that the subject is unaware of your presence with a camera. (This is where a smartphone camera can be useful, because we are all increasingly accepting that most people will have one of them in their possession.)

- If there are other people around, you can try blending in with them or place yourself behind an object such as a car or a pillar (but make sure it does not look as though you are spying on the subject).

- Another, perhaps better, option is to use the zoom function on the smartphone camera. This will enable you to stand far enough away from the subject so that they do not realize you are trying to photograph them.

- Patience is the key when capturing candid shots: sometimes you will have to wait several minutes until you get the right image (since you cannot tell the subject what you want them to do). In some ways it is similar to capturing images of wildlife, in that you have to make yourself inconspicuous and then be prepared to wait.

- Do not try to take candid portraits, or any other kind of photos, of sensitive subjects such as military personnel, particularly if they are near to military installations or airfields.

Close-Ups for Detail

When taking portraits it is usually most effective when they fill the frame as much as possible: it is disappointing to get the perfect portrait of someone, but they are only just visible in the background.

1 When taking portraits, try to get as close as is reasonably possible without crowding the subject. If required, zoom in, within reason, to fill the frame without having to be too close to the subject. Converting images to black and white can also give an extra artistic touch to portraits

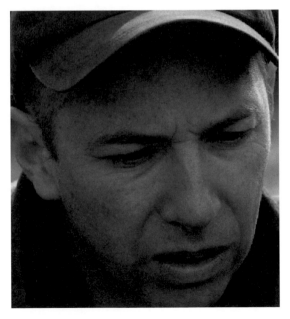

2 Capturing close-up portraits is an excellent way to display the character of a person, particularly for older people

Making it Child's Play

There are probably more photos of children taken on smartphone cameras than any other subject. However, there are several considerations when trying to get the perfect shots of children.

- One of the main issues when capturing images of children is that they tend to perform a passable impression of perpetual motion. They are rarely still for very long so it can be a challenge to try to capture effective images of them. Patience is definitely a virtue when it comes to taking photos of children.

- Portraits of children are familiar photographic subjects and there is absolutely nothing wrong with a standard, face-on portrait.

- In addition to portraits, try to capture photos that offer something slightly different: put the child in an unusual or picturesque location or include additional elements in the image such as flowers or family pets.

- Capturing images of children involved in an activity is an excellent option too. This is because their attention is diverted and there is also the activity itself to help make the image more interesting.

- If you are taking photos in public areas that could involve other people's children, you should ask permission from their parents/guardians: people can become understandably anxious if they see a stranger taking photos around their children.

- Be careful if you are sharing photos of your children on social media. Make sure that there are no other children in the shots (unless you have gained permission from their parents/guardians), and remember that once photos are on the web it is likely that they will stay there indefinitely: even if you delete them, their digital footprint can remain.

Blurring the Background (1)

A very effective technique for taking portraits of people is to blur the background behind them, so the subject stands out more against a softer background. This can be done in a photo-editing app, and it can also be done if your smartphone camera has a portrait setting. To do this:

1 Open the **Camera** app

2 Select the **Portrait** option, if available

3 Select a lighting option and take the photo

4 The background behind the subject is automatically blurred. In some photo-editing apps, the blurred effect can also be enhanced digitally

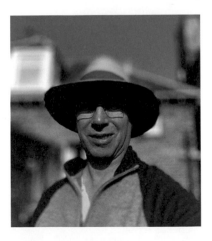

Getting Into the Shot

As shown in Tip 8, the self-timer on a smartphone camera can be used to take a photo at a predetermined time after the shutter button has been tapped. This can be useful for including yourself in group shots, and it can also be used to capture a photo of yourself in front of a notable landmark or building, if there is no-one else there to take your photo. To ensure this is as good as possible, a little preparation and planning is required.

1 Take a shot of the scene in which you want to include yourself

2 Review the photo and work out where you want to stand when you include yourself

3 Put a marker of some sort on the ground at the point where you want to stand (this will make it easier to get to the right spot while the timer is counting down)

4 Position the smartphone, preferably using a small tripod or a small beanbag (make sure that it is not too far away and keep an eye on it in case someone tries to steal the smartphone while it is unattended). Check that the scene is the required one when viewed through the camera

5 Activate the self-timer for the longest time available (to give you enough time to get into position) and tap on the shutter button

6 Position yourself at the marker created in Step 3

7 Review the photo and make any positional adjustments as required

Creating Silhouettes

The lighting conditions during a sunset or a bonfire are ideal for silhouettes. This results in the main subject being completely under-exposed so that they appear black, with the background still retaining some color. This is best done in low-level lighting, and taking the exposure from the background rather than the main subject:

1 Point the smartphone's camera at the background and press on the screen at the point where you want to measure the light reading for the exposure. Press on the screen until the **Auto-Exposure Lock** button appears

2 Reposition the smartphone so that the scene is composed correctly

3 Take the photo. The main subject should be under-exposed to the point where it is dark

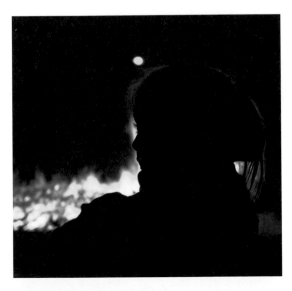

Organizing a group of people for a photo can sometimes be a fraught task: trying to get them together and then ensuring that they have the best expressions. In situations like this you have to think of yourself as a bit of a film director: plan the shot first and then take control of the group and, if necessary, take a bit of time to organize them correctly.

● Try to avoid a shot with everyone standing with their arms at their sides looking directly at the camera. If possible, arrange people to be doing something eye-catching. Also, pay some attention to what they are wearing so this can be a positive part of the photo too. Try to co-ordinate colors, or arrange them in specific patterns; e.g. keep certain colors together and arrange people in order of brightness of clothing.

● Ask people to stand side on or at an angle, so that they are not facing straight-on to the camera.

● Perform a pre-arranged action for the group – e.g. on the count of three, everyone throws their arms up in the air, at which point you take the photo.

● Try to position the group either above or below you. Staircases are good for this: either arrange the group going up a staircase and capture the photo from the bottom or go to the top of the staircase and take the photo looking down on the group below. Although these are now slightly clichéd shots, they are nonetheless still effective.

● At an event such as a wedding, one of the quickest and easiest ways of capturing large group shots is to just copy the official photographer (if there is one). They will create all of the poses and you can then stand beside or behind them and capture the same images (try to stand just behind since if you are at the side, the group will be looking at the photographer rather than you).

Follow Your Own Style

Famous painters have their own unique styles that are often easily recognizable. Whether it is the subject matter, composition, or use of light, it is possible to identify some painters at a glance. The same is true for a lot of famous photographers, who create their own artistic style. However, you do not have to be a famous photographer to create your own style, and these are some of the areas that you can concentrate on to make your photos stand out:

- **Subject matter**. Specializing in a particular subject is a great way to give your photography an overall style. Photographers specialize in numerous areas of photography: fashion, landscape, architecture, animals, royalty, portraits, sport and food to name a few. Pick some of your favorite subjects and practice taking photos of these as much as possible. This way, you will become known among family and friends as having a particular style based on your subject matter.

- **Use of light**. This is a great way to develop a specific style: try taking photos in particular lighting situations – e.g. at night or at the beginning of the day – and use this for as much of your subject matter as possible.

- **Black and white**. This can create very artistic photos and can be used to develop a style that stands out against the majority of color photos that are produced. Black and white photos can be created when a photo is taken with a smartphone camera, usually by using the appropriate filter, or in a photo-editing app once the photo has been taken. If possible, create photos in black and white when the photo is taken.

- **Use of effects**. Specific color effects are another way to develop your own style. This can be done by using the same filters when taking photos or by using photo-editing apps to enhance the color when a photo has been taken. If using effects in this way, use the same ones regularly to create a consistent style.

As well as creating memories that can last a lifetime, photography should be fun. When taking photos with a smartphone it is easy to take several variations of the same scene and instantly review the results. This means that you can experiment with different techniques to create different effects. Some areas to consider include:

● **Humor**. This is very subjective in any walk of life, and this includes photography. The one guide to follow is: if you think something is humorous, then take a photo of it (as long as it is not offensive in any way). This can include incongruous items that do not usually fit together, people in unusual situations, or staged photos such as people appearing to be leaning against the Tower of Pisa or showing the height of the Eiffel Tower between their fingers. If you are staging a photo for humorous effect, make sure that no-one is put in a dangerous position – no photo is worth risking health.

● **Camera angle**. Instead of using a horizontal or vertical view, try using the camera at a different angle, such as 45 degrees. This may not always produce effective results, but occasionally a photo may be taken that is original and worth keeping.

● **Camera movement**. Usually, good photography relies on the camera being kept as still as possible. However, for something different, try moving yourself or the smartphone camera while taking a photo. This can include turning around when taking a photo or, if you are brave and careful, turn on the self-timer and throw the smartphone into the air just as the photo is due to be taken (but make sure you are somewhere with a soft landing if you fail to catch the smartphone).

● **Breaking the rules**. Experiment by changing the normal point of focus or exposure by using the focus or exposure lock feature on an area that is different from the one you would normally select.

Certain substances really lend themselves to photography, and water is definitely one of these. Whether it is the sea, lakes, waterfalls or fountains, there are numerous photographic opportunities involving water all around us. Some techniques when photographing water involve being able to change the manual settings on a camera so, for a smartphone camera, it may be necessary to download a camera app that enables you to set the shutter speed of the camera; i.e. how long the shutter remains open when taking a photo. This can be used accordingly to create artistic effects when taking photos of water:

● Use a slow shutter speed to create the impression of movement with water. Within the camera app, this should be set at 1/30th of a second (approximately, depending on the camera app), or slower (lower).

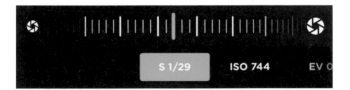

● Use a fast shutter speed to "freeze" the appearance of water so that it can be seen more clearly, to the point of viewing individual drops. Within the camera app this should be set at 1/500 of a second (approximately, depending on the camera app), or faster (higher).

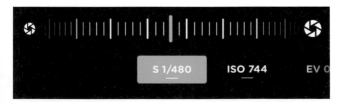

Eye-Catching Still Life

Still life images are perhaps more commonly associated with paintings, but it is a subject that should not be overlooked for photographic images. In simple terms, a still life is an image of a collection of inanimate objects. These can be arranged in an artistic or a humorous way and the end result is frequently in the eye of the beholder.

Creating still life images can be an art in itself, and it is sometimes easier to find still life scenes that other people have created and then use these in your images. Good areas to look at are businesses that are trying to attract people into their premises, as this is often done with eye-catching still life designs. Shops, restaurants, cafés and pubs often have still life displays near their doorways: it is usually better to look around areas with smaller, more specialized outlets rather than large malls or shopping centers. If you find a still life composition that you like you can also try to recreate it with your own items.

If you want to create your own still life images you will first have to create the still life itself. This may depend on your artistic ability but try to follow a few general rules:

- Base your still life scenes on single themes, such as food, art, sport or technology. This is not to say that you cannot have unconnected objects for emphasis, but try to choose the majority of the items from the same general group. Then, arrange the items so that they can all be viewed (or at least parts of them can).

- Keep smaller objects more towards the front and larger ones at the back, and try to aim for an even composition; i.e. one in which nothing looks out of place. The element on which the still life is placed is also important: there is little point having a well-crafted still life that is on a nondescript table.

- Treat every element in the still life as a crucial one.

Recreating Scenes

There is no copyright on a scene, so if you see a photograph or a painting that you particularly like, there is no reason why you cannot recreate it yourself with your own photo of it.

When recreating scenes you have to first find one that is realistic to recreate. A good source of material is travel guidebooks or travel websites. These frequently use impressive photos of locations, and if you like a particular scene or a specific landmark you can start preparing to recreate the scene as accurately as possible. To do this:

● **Work out the location of the scene**. This may be obvious if it is a well-known landmark such as the Eiffel Tower, but for some scenes it may take a bit more research. If you know the general location, search on the web for more details or post a question on a travel forum asking about the location.

● **Identify the angle from where the scene was taken**. In some cases this may be directly in front of the subject, but in others it may be from an angle or above or below the subject. Drones are increasingly used for outdoor photography, so if a scene looks like it has been taken from the air, this is how it could have been achieved. If this is the case, and you do not have access to a drone, you may have to admit defeat in capturing a scene in this way.

● **Check the lighting for the scene**. Work out where the sun is positioned in relation to the main subject, and use this to determine the time of day at which the photo was taken.

Scenes can also be recreated in a humorous way – e.g. you can recreate your own versions of paintings that you like, particularly famous portraits. This can take a bit of time and depends on your creative abilities, but it can produce some fun and effective results.

Special effects have been applied to photos since almost as soon as the process was first invented. Now, through the use of photo-editing apps, it is possible to apply a huge range of special effects to photos. This can be done directly on a smartphone once a photo has been taken, and there are also apps that will apply special effects to a scene, so that the photo is captured with the effects already applied. Special effects apps can create artistic effects and also fun and humorous ones. To add special effects to your photos:

1 In your smartphone's related app store, search for **photo effects apps**

2 Review the apps and download any that you want to try

3 Select an effect before taking a photo. The effect will be applied to the photo. A lot of photos that are published on social media sites, such as Instagram, have had special effects applied in order to enhance them, or just for fun

Car Lights at Night

Night time is an excellent period to explore creative photographic opportunities, particularly in cities where there is a lot of artificial light that can be exploited. One option is to create streaks of light using car tail-lights. This is done by using a long shutter speed for the camera; i.e. the shutter remains open for a relatively long time to capture the light for a period of time as the car passes. To do this on a smartphone camera, a third-party camera app will usually be required to access the functionality of changing the shutter speed. When capturing car tail-lights at night, try the following approach:

1 Select a location where you know there will be enough cars passing by

2 Make sure you are not physically on the road

3 Make sure the smartphone is held as steady as possible, preferably with a small tripod

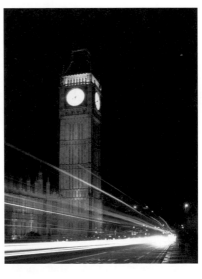

4 Set a long shutter speed in the camera app. This should be at least two seconds, if possible, but the longer the better in terms of capturing the final effect

Showing the size of a building or piece of architecture is an excellent way to display its context. Different techniques can be used to show the imposing nature of a building, or represent it as a small part of its surrounding area. Either way, it is a useful option for revealing some of the character of a building.

The size of a building can be emphasized by capturing an image from directly below it. This creates a sense of perspective and can be used to exaggerate the size of a structure. This can involve getting as low to the ground as possible, and even lying down on the ground to be able to point the smartphone camera upwards 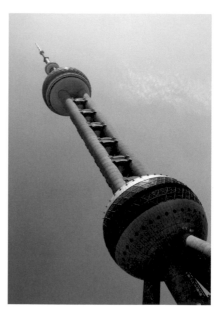 while still being able to see what is on the screen. If you do this, make sure that it is safe to do so without impeding other people or traffic.

Another option for emphasizing the size of a building is to make it look relatively small compared with its surroundings, even if it is a large structure. The best way to do this is to use a wide shot to capture as much of the surrounding area as possible. If there are other objects in the picture that can be used to contrast with the size of the building, then so much the better.

Getting Inside

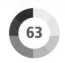

Light is one of the essential ingredients for any photograph, but this does not mean that you must have bright sunlight to capture a good image. Indeed, with a bit of planning and experience, it is possible to take good pictures in any lighting conditions.

One area about which people are sometimes unsure is taking pictures indoors. In a lot of cases this will result in the photographer immediately activating the flash on the smartphone camera. Sometimes this will work, but only if the subject is within range of the flash. However, for a large indoor area such as the interior of a church, the flash will be ineffective: it will light up a small area in the foreground while the rest of the image will look too dark. Instead of using the flash, a more versatile implement for indoor photography is a small tripod or beanbag to keep the smartphone as steady as possible. This will give the smartphone camera the best chance to capture as much of the available light as possible. Smartphone cameras are usually quite forgiving in terms of capturing images in low-level lighting conditions, but keeping it as steady as possible will increase your chances of an effective photo indoors.

If you are using a camera app that enables you to change the shutter speed of the smartphone camera, use this to select a slow shutter speed so that as much light as possible can be captured by the smartphone camera, without the need for flash. In this instance, ensure that the smartphone is kept as stable as possible, as a slower shutter speed increases the risk of a blurry photo from the smartphone shaking slightly. Also, change the ISO setting to 800, or higher, (which enables photos to be taken more clearly in low-level lighting).

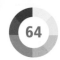
Shots of buildings are frequently taken as straight-on, two-dimensional photos. While this can create highly effective photographs, it would be wrong to concentrate on this type of image exclusively. Buildings are frequently a fascinating combination of curves and angles that can create a much broader context for photos.

All buildings have angles and these are a rich source of photographic opportunities. Angles can be used to emphasize the size of a building, and this gives it a completely different character from that seen in a straight-on shot from further away. For this it is essential to find the right spot from which to capture the angles of the building or structure.

Buildings are best captured at an angle 45 degrees from the corner. This gives a sense of perspective, showing more than one side of the building.

It's All in the Detail

By their very nature, most buildings are made out of numerous small elements that are combined to create the whole structure. However, sometimes when taking photos we concentrate on the overall building rather than its constituent parts. This can be a great oversight, as there is a wealth of photographic material in the detail of buildings.

Details help to convey the character of buildings, rather than their overall appearance. This can cover a multitude of elements: windows, door handles, artwork, tiles, and stone structures. In fact, almost anything that is part of a building.

A useful way to capture detail in a building is to start from a distance from where you can capture the whole building and then work your way closer and closer to capture the details. This can be used as a series of photos to show different aspects of the same structure, and each of the photos should be able to stand up in its own right as well.

Dealing With Distortion

One problem with lenses in smartphone cameras is that the glass is slightly curved: in certain conditions this can result in elements within an image looking distorted. This tends to be particularly obvious in images of buildings with towers or spires. The problems can be made worse if zoom is used.

If your images of buildings suffer from distortion there are a few options for trying to rectify this. One is to position the main subject in the center of the frame rather than at one of the sides. Another step is to move further away from the subject: the closer you are, the more pronounced the distortion. If you are further away from the subject then the curve of the lens will be more forgiving. Similarly, if there is already distortion in an image, the use of zoom will exaggerate this even further.

Another option for dealing with distortion is to try to remove it once a photo has been taken. This can be done with a photo-editing app, if it contains this functionality. The results are not always perfect, but they can go some way to remedying the problem.

Stepping Out

The design of staircases and walkways can be a fruitful source of interesting and eye-catching photos. Some options to look for are:

- Zigzag staircases, such as those on the outside of buildings that are used as fire escapes.

- Spiral staircases. The longer the better in terms of photographic opportunities: go as high up as possible and take a photo trying to incorporate as much of the staircase as possible. This will capture the pattern of the staircase and also the sense of height.

- Walkways that give a sense of direction to a photo. A curved design can give an extra dimension too.

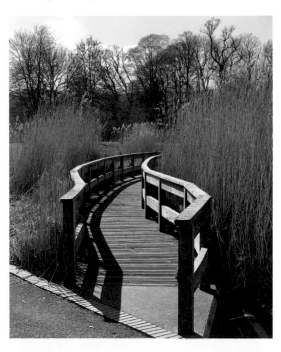

Getting the Iconic Shot

Although it is good to be unique and original when taking photos, there are also times when it is desirable to capture an iconic shot of a building or landmark. This does not mean that you cannot then try to take some more unusual shots of the same subject (see Tip 70), but it can be satisfying to know that you have an image that is instantly recognizable. When capturing iconic shots of buildings or landmarks:

- Make sure that you get the right lighting conditions. This may be the Golden Hour, when the sun is just rising or setting, and it is usually preferable to have the sun behind you so that it illuminates the subject. If possible, research the subject before you take a photo of it, and check what the light looks like at different times of the day.

- Once you have checked the lighting conditions, wait until the light is exactly as you want it.

- If there is a large crowd of people around the subject, wait until as many as possible have dispersed, so that you can concentrate on the subject on its own.

- Use a postcard of the subject to work out the best location to stand when capturing it.

- Take numerous shots to make sure that you get the perfect end result.

Adding Interest

The human eye is naturally drawn to objects or items that stand out in an image or photo. For instance, a contrasting color or an unusual object will catch the eye, such as within landscape or city scenes. When taking photos in these types of locations it is always a good idea to try to look for objects of interest and include them in the scene in some way. It can also include an area of a photo that adds something to the overall scene.

Objects of interest can include almost anything depending on the scene. For instance, a red flower in a field of white ones will catch the attention, as will an incongruous object in a city scene, such as an old bike leaning against a new state-of-the-art building.

When using objects of interest within a scene the aim is to try to create a "road map" that can guide the viewer through the image. Ideally, they should notice the object of interest first and then be able to follow their way through the rest of the image from there. This means that it is best to locate the object of interest at the front of the photo (although not necessarily in the center), from where the viewer can then look at the rest of the photo.

Once you have captured some "standard" shots of a famous building or landmark, you can then concentrate on finding a location from where you can capture more individual and artistic shots. This can put more of your own stamp on a scene, rather than just having a picture postcard shot of it. Standing out from the crowd in photographic terms can take a bit more time and effort, but it will be well worth it when it comes to viewing your photos.

- The first thing to do is literally get away from the crowds. Every tourist landmark around the world usually has a large group of people standing directly in front of it, so your first task is to find different places for taking your photos. Walk around a building or landmark and look at it from every angle (depending on the building or landmark this may take some time but it is worth persevering with). Then you will be able to assess potential shots that show the building or landmark in a different context from the standard view.

- Look for close-ups to show the building's character; use the building's angles to show symmetry and patterns and change your own angle to alter the perspective (try getting above the building and also lying down and shooting from directly below parts of the building).

- Even if you manage to find what you think is a unique location for taking photos of an iconic landmark, it is unlikely that you will be completely alone. Sometimes it is a case of just waiting until other people have left until you can take photos without anyone else around.

- In some locations, cruise ships visit regularly, and large groups then descend on the sites throughout a city or town. To try to avoid this, check out the days and times at which cruise ships will be visiting and plan your photography accordingly. (Schedules can usually be found from the cruise ships' website and hotels.)

Rising Above the Rest

One way to get an original photo of a building, a landmark or a landscape is to get as high as possible above a subject. This can involve climbing a nearby hill, or going to the top of a tall building. However, another option is also now available to the keen photographer: using a drone. These are remote controlled aerial devices that can carry a smartphone so that photographs and videos can be taken from above. Although they are now widely available, drones are still relatively expensive and only really a realistic investment if you want to take aerial photography seriously. However, it does give you the opportunity to create some stunning photographs and videos.

If you do take the plunge and use a drone for taking photos and videos with your smartphone camera there are some issues that should be considered:

- Safety should always be paramount when using a drone. Never use it anywhere where there could be aircraft of any sort, or near to a military installation of any kind. If in doubt about a certain location, do not send your drone into the air.

- Never use a drone near to power lines as this could cause serious damage to both.

- Always make sure that your drone has enough battery power for whatever task you want it to perform. The drone will come to ground when the battery runs out, and if this is over water you may not be able to retrieve it.

- Drones are noisy, so be careful about using them for too long in residential areas as it could start to annoy the residents.

- Be careful using drones near prisons, as they have been known to be used to fly contraband over prison walls.

Spotting Bands of Color

Color is all around us, and the human eye can differentiate millions of different colors and shades. In photographic terms, color is an essential ingredient, but it is not always necessary to include as many colors as possible for effective images. It is always good practice to think about color in images and the best way in which it can be used.

One way to use color in images is to show an extravagant or vibrant event such as a festival or a carnival. Colorful costumes and designs can then be used to capture a flavor of the event, and it is an excellent way to get some very striking images.

Another perhaps more understated way of using color is to look for large blocks of color in a scene and see if they can be incorporated into a meaningful image. Bands of color can be used either horizontally or vertically; three good options are the sky, the sea, and grassed areas such as fields and parks.

The use of bands of color can be made to highlight other items in the image by creating a "sandwich" effect. This is where the bands of color are above and below the main subject. This displays the center area as the filling in the sandwich, while the colored areas are still noteworthy in their own right.

Let Me Tell You a Story

Some photographic locations offer the chance for one single, stunning image. However, in most cases there are numerous opportunities for capturing a variety of images. Even if you cannot immediately see the chance for different images it is always worthwhile looking around a location to see if you can capture a range of shots. Once you have perfected this you should be able to create a photo-essay in almost any situation. This is a collection of images that together give a sense of the character of a location.

Wherever you are with your smartphone camera try to think of the different types of shots that are available. For instance, if you are on holiday on the beach:

● Take some shots of your family playing in the sand.

● Have a look at the sea and the waves and try to capture some artistic shots of the water and any waves that are visible.

● Take a walk along the beach and look in rock pools for any signs of life. Also, take some texture shots of the rocks and plants themselves.

● Take some photos of any people who are working on the beach, selling souvenirs or refreshments.

● Take some shots of any activities that are on offer, such as paragliding or jet skiing.

● Finally, at the end of the day capture some social shots of people leaving the beach, to contrast with the action and enjoyment of earlier in the day. Look at the obvious and then try to enhance this with as many different types of shots as possible.

If you try to create a photo-story rather than just taking random photos, the end result will create a much more interesting collection.

Stitching Panoramas

When faced with an impressive landscape or cityscape scene, one good photographic option is to take a panorama. This is a photo when two or more photos are combined to provide a wider final photo that can be captured in a single shot. Some smartphone cameras have a function to create panoramas automatically using the camera app. To do this:

1 Open the Camera app and tap on the **Pano** option

2 Tap on the **Shutter** button

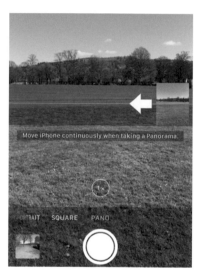

Move iPhone continuously when taking a Panorama.

PORTRAIT SQUARE PANO

3 Move the smartphone camera slowly along the whole panoramic subject

4 Tap on the **Stop** button to complete the panorama

Another way to capture a panorama is to take the required photos individually and then stitch them together using a photo-editing app. When capturing images for a stitched panoramic scene, make sure that you capture the different images from the same location and overlap each image by approximately 20% so that the stitching appears seamless.

When the Sun Goes Down

Sunsets can be one of the most impressive and evocative types of photo. Done properly they can provide a stunning memory. However, all too often they fail to do the original scene justice. Some rules to follow to try to make the most of impressive sunsets:

● Try to include additional subjects, not just the sun setting on the horizon with nothing around it.

● Try to make the sunset appear at a reasonable size, not just a speck in the distance.

● Take several shots while the sun is going down: sometimes the best shot is just after the sun has set, particularly if there are clouds around that can be lit up from the setting sun below them.

● Work out where and when the sun is going to set and then plan your photos accordingly, based on the background and any foreground objects that you can include too.

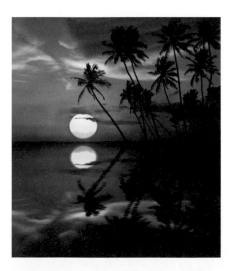

A common maxim in the acting world is "never work with animals or children", but it is not necessarily one that is true in smartphone photography. Certainly, it can take a bit more care and attention and patience to capture good images of children and animals, but the results can be very rewarding.

When capturing images of animals there are two main ways to go about it: either in the wild or in some form of confinement such as zoos, agricultural shows or wildlife parks. In the wild it is a lot harder to get good pictures, and you will need a good zoom option on your smartphone camera and a lot of patience. Rather than chasing after animals, the best way to operate in the wild is to select a spot (and preferably use some form of hide or shelter) and then let the animals come to you. Depending on the type of wildlife this could take several hours, but it is worth remembering that most stunning images of wildlife have probably taken days, or even weeks, to capture. It is rarely just a case of turning up, snapping away for a few minutes and then going home.

For animals in some form of captivity the photographer's job is made easier, if only because you know where the animals are going to be. When you are capturing images in these types of conditions it is also worth being patient so that you get the best possible shots. Try to avoid too much foreground or background detail that reveals your location, and try to get as much of an animal's character as possible.

Food for Thought

Food is another area that occupies a specialized niche in the world of photography, but there is no reason why anyone with a smartphone camera cannot take impressive images of food and food-related items.

When dealing with food try to capture the essence of a particular type of food: the rich texture of chocolate by using a close-up shot, the freshness of an apple by cutting into it and showing the juice lying on the skin, or the size of a hot dog by photographing it length-on and at a low angle so that it fills the frame.

It is also important to make an entire food scene as enticing as possible. If you are photographing a Thanksgiving dinner for instance, include items such as the table setting, candles and flowers so that an overall ambience can be created. Try to create a sense of the dining experience rather than just the food on its own.

One valuable trick when capturing images of food is to do it when it is cold. This means that there will be no steam to cloud up the camera lens. Instead, try covering items with oil, or even wax, to give them that glistening appearance as if they are just out of the oven. This is how a lot of professional food shots are captured.

If you do capture food as it is being prepared, be careful not to get too close to saucepans and frying pans. This is because water or fat could splash onto the smartphone camera lens and spoil the shot, and potentially the smartphone too. Keep your distance and use the zoom function on your smartphone's camera to make the items look closer.

It is increasingly common for food photos to be posted on social media. Rather than just quickly taking a photo of your culinary masterpiece, take a bit of time to create a photo that will be genuinely eye-catching and make it worthwhile for other people to look at.

Once photos have been taken with a smartphone camera, that is definitely not the end of the story. As well as being able to share your photos in a variety of ways, it is also possible to edit and enhance them on your smartphone.

Most smartphones have their own default photos app that can be used to manage and edit photos. The editing functions are usually fairly limited but can be effective. Some options include:

- **Auto-enhance**. This is a one-tap option that enhances the overall look of a photo.

- **Cropping**. This involves dragging a rectangle over an area of a photo that you want to keep, and deleting the area outside the rectangle to emphasize the main subject.

- **Color enhancements**. These include manually adjusting the overall exposure of a photo, the brightness and contrast, and the saturation of color.

- **Filters**. Instead of adding filters when taking a photo, they can also be added using a photo-editing app.

Finding New Editing Apps

As well as using the smartphone's default photo-editing app, there are numerous other ones that can be downloaded from your smartphone's default app store. These usually have a greater range of functionality than the smartphone's default version. Enter **photo editing apps** into the app store's Search box and review and download the options as required.

Some photo-editing apps offer a range of editing functions similar to those found in the smartphone's default Photos app, but are often more extensive.

Other photo-editing apps concentrate more on special effects or fun features.

More comprehensive photo-editing apps can be used on computers once photos have been downloaded there from a smartphone. One of the most widely used of these is Photoshop Elements.

From Phone to Computer

Smartphones are excellent for displaying photos that have been taken with them. However, there may also be times when you want to transfer photos from a smartphone to a computer. This could be to undertake more sophisticated photo-editing than perhaps can be done on the smartphone, or to display your photos as a slideshow on a larger screen. There are several ways to transfer photos:

- Cable connection. Use the USB cable that is provided with the smartphone (which is also used to charge the smartphone) to connect it to the USB port of a computer. This will show up as an external drive in your computer's file management system (File Explorer for Windows or Finder for Mac computers). Double-click on the smartphone name to open it to download the photos on it. Select the required photos and copy them. Then paste them into a folder on your computer. In some cases, on Windows PCs, there is also an option to right-click on the smartphone name and select to **Import** the photos from the smartphone.

- Bluetooth transfer. To do this, ensure that Bluetooth is available and turned on for the smartphone and the computer and then **Pair** the devices so that they can communicate with each other. The Pair request will appear on one or the other of the devices; select this to start the pairing process. Once this has been done, photos can be transferred from the smartphone by selecting the photo in the Photos app and then using the Share option and selecting Bluetooth as the sharing method. The photos should be transferred to the paired Bluetooth device.

- Email photos to yourself from the smartphone and open them from your email account on your computer.

- Share photos to a cloud service, such as iCloud, Google Drive or Dropbox, and access this from your computer, either from an app or the related website.

Auto-Enhancing Photos

One of the quickest editing functions is the auto-enhancing option. This is a one-tap function that automatically enhances the color features of a photo, such as color, contrast, brightness, and saturation. To do this:

1 Open a photo at full size in a photo-editing app

2 Tap on the **Edit** button Edit

3 Tap on the **Auto-Enhance** button

4 The color features of the photo are automatically enhanced. The effect can be reversed by tapping again on the **Auto-Enhance** button or on the **Cancel** button

One of the most versatile techniques with a photo-editing app is the ability to select specific areas within a photo. Once this has been done, several actions can be applied to the selected area (and not the rest of the photo):

- The color of the selected area can be edited.

- The selected area can be deleted.

- The selected area can be filled with a solid color.

- The selected area can be copied and pasted into another location (within the same photo or another).

- The selected area can be inverted to select the rest of the photo instead.

When selecting areas of a photo there are usually several options that can be used (depending on the editing app):

1 Use the **Lasso** tool to create a freehand selection by dragging over the photo

2 Use the **Polygonal Lasso** tool to create a selection by clicking on points on the photo that form the selection, in a dot-to-dot pattern

3 Use the **Magnetic Lasso** tool to create a selection by dragging around the area to be selected. The tool will tailor the selection according to the colors that are around the border of the selection, to avoid unwanted areas

4 If available, use a **Magic Wand** tool to select an area of similar colors

Blurring the Background (2)

As shown in Tip 51, an effective technique for portraits is to blur the background behind the subject. In addition to doing this when a photo is being taken, it is also possible to create the same effect in a photo-editing app. Indeed, using an app can be more effective, as the amount of blurring can be amended. To do this:

1 Open a photo in a photo-editing app and use one of the selection tools to select the area behind the main subject that you want to blur

2 Select the appropriate blur option to apply to the selected area. In some apps this will be to manually blur the background with one of the **Blur** options

3 Alternatively, some apps have an auto option that creates the blur effect automatically. In photographic terms this is known as Depth of Field

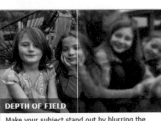

DEPTH OF FIELD

Make your subject stand out by blurring the background.

Cropping Effectively

Even in well-composed photos there is usually some potential for removing unwanted areas of the background. This is known as cropping and is used to make the main subject more prominent in a photo. Cropping is done by drawing a rectangle around the subject that you want to use, and the rest of the background is removed:

1 Select the **Crop** tool in a photo-editing app

2 Drag the **Crop** tool around the area to be retained

3 Release the Crop tool (or in some apps, click on the tick button, or Accept option) to remove the background. Some apps also have options to crop photos proportionally – e.g. with a specific height and width ratio

One straightforward way to enhance the color of a photo
in a photo-editing app is to use the brightness and contrast
option. This alters these two elements of a photo, and is
a quick and effective way to make your photos stand out.
However, another option in some photo-editing apps is to
use the Levels function. At first sight this may seem slightly
daunting, as it contains a graph that depicts the tonal range
of the colors in a photo. In reality this is another quick
way in which the overall appearance of a photo can be
improved. To use the Levels function:

1 Open a photo-editing app that contains the Levels
function and access it (usually from the app's
menu or menu bar)

2 Drag the left-
hand marker
to change the
darkest elements
of a photo
(Shadows).
The further to
the right that
the marker is
dragged, the
darker the photo

becomes (this can be useful if a photo is over-
exposed – i.e. too light)

3 Drag the middle marker to change the midtone
colors in a photo – i.e. those between the darkest
and the lightest points

4 Drag the right-hand marker to change the
brightest elements of a photo (Highlights). The
further to the left that the marker is dragged, the
lighter the photo becomes

Using Color Blocking

An effective option when editing photos is to make one area stand out from the rest of the photo. One way to do this is with a technique called color blocking. This involves making the image black and white, except for the subject that you want to highlight. This can be done with photo-editing apps: some have a specific function for undertaking color blocking, and it can also be done by selecting an area and turning it to black and white. To do this:

1 Open a photo in a photo-editing app and use one of the selection tools to select the area that you want to turn black and white (or select the main subject and **Invert** the selection)

2 Use a color enhancement option that converts the selection to black and white

3 The main subject retains its original color and stands out against the black and white background

Adding or Removing People

Taking photos of people can be one of the most rewarding aspects of photography, as you build up years of memories of family and friends. However, it can also be one of the most frustrating: at times, unwanted strangers appear in the background of what would otherwise have been a perfect family shot; or one person is not available when a notable photo of family or friends is taken. This can be resolved with a good photo-editing app, where it is possible to either add or remove people from photos:

1 To remove people, look for an app that has this functionality. The process involves selecting the person to be removed with one of the selection tools.

PHOTOMERGE GROUP SHOT

Make sure everyone in your group shot is smiling and has their eyes open by blending multiple shots into one.

Once the person has been deleted, the app automatically fills in the resulting gap in the photo using the background around it

2 To add people to a photo, find a photo of them when the lighting is as similar as possible to the group photo. Use one of the selection tools to select the person and copy the selection. In the group photo, paste the person into the group and position them and resize them accordingly

If you know that someone is missing from a group photo, make sure that there is space at the side of the group so that it makes it easier to insert the missing person at a later date: if there is no space it will be much harder to incorporate them into the group photo.

Spots and blemishes are part of life, but it can be a lot easier to remove them from photos taken on your smartphone camera, if you want to. Look for photo-editing apps that contain this function; in some cases it will be with a tool called the Healing Brush. To use this:

1 Open a photo of someone that contains spots or blemishes (or other elements you want to remove, such as wrinkles)

2 Select the **Healing Brush** tool

3 Position the Healing Brush tool over a clear area that you want to use to copy over the blemish (with some photo-editing apps, on a computer, this area is selected by holding down the Alt key and clicking on the area)

4 Drag over the area affected by the blemish. The area selected in the previous step will cover over the blemish and merge the colors to give as natural an effect as possible

Built-In Cloud Services

Cloud services are online facilities for storing and sharing a wide range of data stored on personal computers, tablets and smartphones. One of the most common uses of cloud services is for storing photos, which means that not only are the photos backed up – i.e. saved somewhere other than on the device on which they were captured – but it also means that you can access them by logging in to your cloud service from another device. Photos can also be shared with other people via cloud services. Depending on the model of smartphone, there will be a different cloud service available:

- iPhones use the Apple cloud service: iCloud.

- Android phones use the Google cloud service: Google Drive.

Regardless of the cloud service being used, once it is set up, your photos will automatically be saved there as well as on your smartphone. To do this:

- On an iPhone, access **Settings** > **Apple ID** and tap the **iCloud** button to **On**.

- On an Android phone, download the Google Drive app and log in to it using your Google Account details. (This can also be used on an iPhone, if you have a Google Account set up.)

Third-Party Cloud Services

In addition to built-in cloud services, there are also third-party ones that can be used as well as, or instead of, the default ones. The most widely used third-party cloud service is probably Dropbox. This offers a free service with up to 2GB (gigabytes) of storage. This can be upgraded for a fee. One advantage of using Dropbox is that it is not tied to any specific device or operating system. On the downside, it means that content is not automatically stored in Dropbox, and items have to be stored there manually.

To use Dropbox for storing photos and other content from your smartphone:

1 Download the Dropbox app from your smartphone's default app store

Dropbox

2 Tap on the Dropbox app and create a free account with an email address and password

3 Once a Dropbox account is set up, content can be added to it by using the **Share** button from an app on your smartphone, such as within the Photos app (see Tip 92)

4 Tap on the **Dropbox** option for sharing an item

5 Alternatively, within the Dropbox app, tap on the **Create** button and select the **Upload Photos** or **Create or Upload File** option

+
Create

🖼	Upload Photos
⊡⁺	Create or Upload File

Creating Photo Albums

It can be easy to take hundreds or thousands of photos with your smartphone camera and store them in your smartphone's Photos app. What can be more of a challenge is to be able to find the photos you want, when you want them. One way to make this easier is to create albums to store photos covering similar content, or taken on a specific date, or in a single location. To do this:

1 Open the smartphone's Photos app and tap on the **Albums** button

2 Tap on this button to create an album

3 Give the album a name and tap on the **Save** button

4 Tap on photos to select them for the new album and tap on the **Done** button

5 Once an album has been created, photos can be added to it by selecting them and tapping on the **Add To** button

Sharing the Fun

Smartphones make it possible to quickly share your photos with family and friends using a variety of options, including email, messaging, and social media. The immediacy with which photos can be shared is one of the benefits of using a smartphone camera rather than a digital camera. To share photos directly from your smartphone:

1 Open the smartphone's Photos app and either open a photo at full size, or select one or more photos

by using the **Select** button and tapping on the photos to be selected

2 Tap on this button to share the selected item(s)

3 Tap on one of the options for sharing the selected item(s). This includes email, messaging, and any social media sites that you have linked on your smartphone. It is also possible to share photos to an existing album that you have created, or copy the photo(s)

Creating Slideshows

Photos taken on a smartphone are excellent for displaying on desktop computers and laptops as slideshows, once they have been downloaded. However, it is also possible to create slideshows for use on the smartphone itself. Although this is a smaller screen than a desktop computer or a laptop, it is an ideal way to quickly display your photos in an artistic way. To create slideshows on your smartphone:

1 Open the smartphone's Photos app and select two or more photos to be used in the slideshow, by using the

Select button and tapping on the photos to be selected

2 Tap on the **Share** button

3 Tap on the **Slideshow** option

4 The selected photos will be displayed with accompanying music and automatically move between photos, with a creative transition effect. Tap on a photo and tap on the **Options** button to select different options for how the slideshow operates, in terms of music, transitions between photos, and the overall speed of the slideshow

Using Tags

One way of making photos easier to identify and find is by giving them a specific tag. This can be done with photo-editing apps on your smartphone that have this functionality, and also with more powerful photo-editing apps once the photos have been downloaded to a desktop computer or laptop. To do this:

1 Select the required photos in the photo-editing app

2 Create a tag to be used for the selected photos

3 Drag the photos over the tag to add it, or vice versa, depending on the app

4 The tags are added to the photos and these photos will be displayed if they are searched for using a specific tag

Searching for Photos

Some default photo-editing apps tag photos automatically according to the subject matter in the photo (the apps are very sophisticated in identifying what is in a photo), location or date. The app's search facility can then be used to display photos in pre-selected categories, depending on the tags that the photos have been given.

1 Open the smartphone's Photos app and tap on the **Search** option

2 Categories that have already been identified and grouped together are displayed on the Search page

3 Enter a keyword or phrase into the Search box to display any matching items

Auto-Organizing

Smartphone photo apps are becoming increasingly sophisticated, and one function that has been developed is the ability for the apps to auto-organize collections of photos. This is based on date taken, location, and subject matter, and results in what the app considers the best selection of photos for a particular location or event. The resulting photos are then viewed in an album or as a slideshow, saving you the time of having to create these yourself. The process is not always perfect, and some photos that you would want included get missed, but there is also an option for adding more photos manually. Auto-organized collections are usually accessed in a single tap:

1 Open the smartphone's Photos app and tap on the button designated for the auto-organizing function

2 The items that have been created are displayed in albums. Tap on an album to view its contents

3 Tap on the **Play** button to view a slideshow of the album. As the slideshow is playing, tap on it to access editing options, including adding photos

Wireless Printing

Printing your own photos can sometimes be a frustrating and time-consuming business. However, with a smartphone, photos can be sent directly to a printer wirelessly, without the need to physically connect to the printer. To do this:

1 Buy a wireless printer (make sure it has wireless capability) and turn it on

2 If required, download the printer's related app from your smartphone's app store. This will enable the printer to communicate with the smartphone wirelessly

3 Open the smartphone's Photos app and access the photo you want to print

4 Tap on the **Share** button

5 Tap on the **Print** button

6 Make the required selections for the wireless printer and tap on the **Print** button

Another option for printing photos from your smartphone, in addition to doing it on your own wireless printer, is to use an online printing service. There are several of these available and most of them offer a similar service in terms of price, quality and range of printing options: photos, calendars, photo books, mugs, etc.

To use an online printing service (this can all be done directly from your smartphone):

1 Search on the web using **online printing** as the search phrase

2 Review the options and pick one that best meets your needs (several online printing services offer some form of introductory offer)

3 Register with the online printing service, using an email username and a password

4 Once you have logged in, tap on the **Upload** button within the site

Upload

5 Tap on the **Mobile** option (or one of the other options, such as from a social media site) and follow the instructions for uploading photos directly from your smartphone

Upload your photos

Mobile

Connect to Google Photos

Connect to Facebook

6 Once the photos have been uploaded you can select options for how you want them printed, such as size and quantity

Adding Lenses

Although smartphone cameras work exceptionally well on their own, and enable a range of photography, you do not have to stick with just the lens that comes with your smartphone camera. There are numerous lens attachments that can be added to take your smartphone photography to the next level. Two options to look at are:

- **Lens attachments**. These lenses are attached over the existing lens using a large clip, and different lenses can then be swapped as required. The range of lenses that can be used include: telephone lenses, which enable you to get closer to the action; wide angle lenses, which are excellent for capturing landscapes and cityscapes; fisheye lenses, which create a distorted circular effect; and macro lenses for close-ups. Some lens attachments are sold individually, and there are also kits where you can buy several lenses together.

- **Lens covers**. Using a cover for your smartphone is a good idea to protect it from bumps and scratches. However, there are also covers that contain an additional camera lens when it is placed over the smartphone. The functionality is not as extensive as using lens attachments, but it is an excellent way to protect your smartphone and add some functionality to the camera at the same time.

Smartphone Camera Safety

Photos should be a source of fun and joy, in both capturing them and then later viewing them. One thing that can spoil this is if your smartphone is lost or stolen. Or, worse, if you get into trouble because of trying to photograph the wrong things. Some ways to avoid these issues are:

- Use your smartphone's cloud service, or a third-party one, to back up your photos.

- Keep your smartphone with you when traveling by plane: electronic equipment is frequently stolen from luggage that goes in the hold.

- When on vacation, be careful with your smartphone outside the main tourist areas or at night. In some countries, smartphones represent a considerable amount of money so, if in doubt, keep it out of sight.

- In crowded areas, be wary if you are approached by a small group of people. Sometimes this can be used as a distraction while someone else accesses your pockets or backpack. Also, do not carry your smartphone in a loose pocket as it could be an easy target for pickpockets.

- Do not take photos of military installations or non-domestic airfields. Security services tend to take a very dim view of this. Also, do not take photos of military or security personnel.

- If you are taking photos of local people, ask their permission first. In some cases (particularly in very touristy areas) they may ask for a small fee to have their photos taken.

- Keep your smartphone away from water, particularly swimming pools or the sea. They do not react well to water: if your smartphone does get wet, try to dry it out completely before using it again.

Useful Resources

Camera apps
- Halide Camera
- TADAA
- Huji Cam
- Google Camera
- FV-5

Editing Apps
- Adobe Photoshop Express
- Bazaart Photo Editor & Design
- Instasize Photo Editor & Grid
- MOLDIV – Photo Editor, Collage
- PicsArt Photo Studio
- Fotor Photo Editor
- AirBrush
- Pixlr

Special Effects Apps
- EditLab
- Enlight
- LensLight
- ClonErase
- Matter
- Candy Camera
- Facetune

Wireless Color Photo Printers
- Canon Pixma TS9155
- Epson Expression Photo XP-8500
- HP Envy Photo 6234
- Epson EcoTank ET-7750

Notes